# I WANT TO DRAW

## ENDANGERED ANIMALS

WRITTEN AND ILLUSTRATED BY ANTHONY J. TALLARICO

Copyright © 1993 Anthony J. Tallarico
Copyright © 1993 Modern Publishing, a division of Unisystems, Inc.

® Honey Bear Books is a trademark owned by Honey Bear Productions, Inc. and is registered in the U.S. Patent and Trademark Office.

™ I Want To Draw is a trademark owned by
Modern Publishing, a division of Unisystems, Inc.

All rights reserved.

No part of this book may be copied or reproduced
in any format without written permission from the publisher.

Modern Publishing
A Division of Unisystems, Inc.
New York, New York 10022

Printed in the U.S.A.

# BEFORE YOU BEGIN:

The materials that you'll need are --

NUMBER 2 PENCIL
ERASER
DRAWING PAPER
BLACK FELT-TIP MARKER

Start your drawing by lightly sketching. STEP 1. Don't be afraid to erase until you are satisfied with the way your sketch looks. This is the most important step as you will draw all the others on top of this.

STEP 2. Add this step, lightly in pencil, to the first step. Don't be afraid to draw through other shapes or to erase.

STEP 3. Add lightly in pencil. Again, don't be afraid to draw through or to erase lines or shapes you are not satisfied with.

Now you are ready to complete your drawing. STEP 4. Finish your drawing using your black felt-tip marker. Add details and black areas. Erase all pencil marks. You can keep your drawing the way it is, in black and white, or add color.

## HAPPY DRAWING!

# VICTORIA'S BIRDWING BUTTERFLY

STEP 1:

STEP 2:

STEP 3:

STEP 4:

# EMU

STEP 1:

STEP 2:

STEP 3:

STEP 4:

# PRAIRIE DOG

STEP 1:

STEP 2:

STEP 3:

STEP 4:

# ROCKY MOUNTAIN GOAT

STEP 1:

STEP 2:

STEP 3:

STEP 4:

# GIBBON

STEP 1:

STEP 2:

STEP 3:

STEP 4:

# JACKASS PENGUIN

STEP 1:

STEP 2:

STEP 3:

STEP 4:

# GIANT TORTOISE

**STEP 1:**

**STEP 2:**

**STEP 3:**

**STEP 4:**

# GIANT PANDA

STEP 1:

STEP 2:

STEP 3:

STEP 4:

# BROWN BEAR

STEP 1:

STEP 2:

STEP 3:

STEP 4:

# SUMATRAN RHINOCEROS

STEP 1:

STEP 2:

STEP 3:

STEP 4:

# TAPIR

STEP 1:

STEP 2:

STEP 3:

STEP 4:

# ARCTIC FOX

STEP 1:

STEP 2:

STEP 3:

STEP 4:

# MANED WOLF

STEP 1:

STEP 2:

STEP 3:

STEP 4:

# JAGUAR

STEP 1:

STEP 2:

STEP 3:

STEP 4:

# KOALA

STEP 1:

STEP 2:

STEP 3:

STEP 4:

# PYGMY HOG

STEP 1:

STEP 2:

STEP 3:

STEP 4:

# EAGLE

STEP 1:

STEP 2:

STEP 3:

STEP 4:

# PEREGRINE FALCON

STEP 1:

STEP 2:

STEP 3:

STEP 4:

# GIANT ARMADILLO

STEP 1:

STEP 2:

STEP 3:

STEP 4:

# GORILLA

**STEP 1:**

**STEP 2:**

STEP 3:

STEP 4:

# TAMARAU

STEP 1:

STEP 2:

STEP 3:

STEP 4:

# POLECAT

STEP 1:

STEP 2:

STEP 3:

STEP 4:

# TUATARA

STEP 1:

STEP 2:

STEP 3:

STEP 4:

# PRONGHORN

STEP 1:

STEP 2:

STEP 3:

STEP 4:

# BLUE SHARK

STEP 1:

STEP 2:

STEP 3:

STEP 4:

# ALLIGATOR

STEP 1:

STEP 2:

STEP 3:

STEP 4:

# KUDU

STEP 1:

STEP 2:

STEP 3:

STEP 4:

# AMERICAN BUFFALO, BISON

STEP 1:

STEP 2:

STEP 3:

STEP 4:

# INDRI

STEP 1:

STEP 2:

STEP 3:

STEP 4:

# MANATEE

**STEP 1:**

**STEP 2:**

**STEP 3:**

**STEP 4:**

# GIRAFFE

STEP 1:

STEP 2:

STEP 3:

STEP 4:

# BACTRIAN CAMEL

STEP 1:

STEP 2:

STEP 3:

STEP 4:

# COUGAR

STEP 1:

STEP 2:

STEP 3:

STEP 4:

# OSTRICH

STEP 1:

STEP 2:

STEP 3:

STEP 4:

# SPIDER MONKEY

STEP 1:

STEP 2:

STEP 3:

STEP 4:

# AFRICAN ELEPHANT

STEP 1:

STEP 2:

STEP 3:

STEP 4:

# AMERICAN ELK

STEP 1:

STEP 2:

STEP 3:

STEP 4:

# POLAR BEAR

STEP 1:

STEP 2:

STEP 3:

STEP 4:

# ASIATIC ELEPHANT

STEP 1:

STEP 2:

STEP 3:

STEP 4:

# TIGER

STEP 1:

STEP 2:

STEP 3:

STEP 4: